Florida

What's So Great About This State?

There is a lot to see and celebrate...just take a look!

CONTENTS

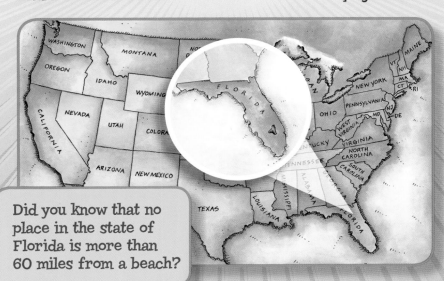

Did you know that no place in the state of Florida is more than 60 miles from a beach?

Well, how about...
the land!

From the Panhandle...

Florida is a peninsula, mostly surrounded by water. The Atlantic Coastal Plains and the Gulf Coastal Plains ring the peninsula and are just above sea level.

The northern part of the state—where it "attaches" to the mainland— is known as the Panhandle. Regions of higher land (the Highlands, of course!) stretch across much of the Panhandle and continue down the middle of the state.

The Northwestern Highlands have gently rolling hills and caves. Farther east are the pine forests of Tallahassee Hills, and the freshwater lakes and springs of the Central Highlands region.

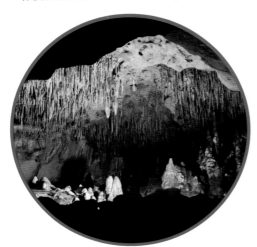

Florida Caverns State Park is in the Marianna Lowlands region of the Panhandle.

Freshwater lakes dot the Northwestern and Central Highlands region of the state.

...To the Keys

The Central Highlands region, which stretches south from the Georgia-Florida border to just north of Lake Okeechobee, has a mild climate and great soil. It's known for the oranges, grapefruits, and other citrus fruits that are grown there.

Most of Florida's people live in the southern part of the state. The land stretching from Fort Lauderdale to Miami is the state's largest metropolitan area. But southern Florida is also home to the largest wetland in the United States—the Everglades.

And guess what? The southern tip of the peninsula is not the end of Florida! There's still a string of about 1,700 islands known as the Florida Keys. The keys are actually exposed parts of ancient coral reefs that lie on a layer of limestone rock.

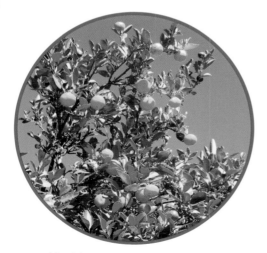

Liquid sunshine (or rain!) helps oranges grow in Central Florida.

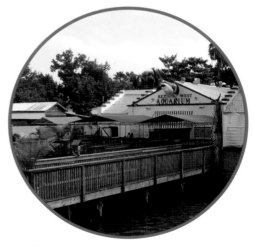

The unique Key West Aquarium is in the Florida Keys.

A beach on Key West

Wetlands

A Great Egret wades in a Florida wetland.

Wetlands cover about thirty percent of the Sunshine State.

Why are wetlands special?
(...and what are wetlands, anyway?)

Wetlands (which include swamps, marshes, and bogs) are areas of low, flat land that act like giant sponges to soak up water. They have wet soil or are covered in water for at least part of the year. Wetlands can be saltwater or freshwater. They help store and clean water. They also provide homes for birds and many other animals.

Where are the biggest wetland areas in Florida?

The Okefenokee Swamp is a huge wetland that spans the borders of Florida and Georgia. However, the Everglades in south Florida is the largest wetland area in Florida—and the whole United States!

What can I see in the Everglades?

How about a River of Grass? The Everglades gets this nickname because a shallow layer of water ripples slowly through billions of blades of sawgrass. Many animals, such as turtles, egrets, and alligators, live in the sawgrass prairies, mangrove forests, and cypress swamps of the Everglades.

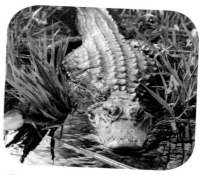

Alligators prefer freshwater swamps, marshes, and rivers.

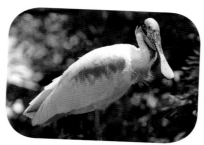

Roseate spoonbills live in wetlands—especially mangrove swamps.

Don't forget the panthers!

You probably won't see one, but there are about one hundred of these endangered animals living in the Everglades. Panthers like to roam where there are few people and plenty of food sources.

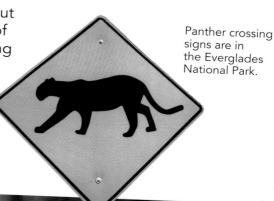

Panther crossing signs are in the Everglades National Park.

Beaches and Barrier Islands

Miami Beach has some colorful lifeguard stands!

With more than 1,300 miles of coastline from the Atlantic Ocean to the Gulf of Mexico, the Sunshine State has some of the best beaches in the world.

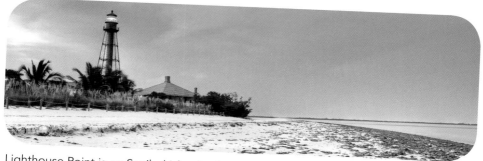

Lighthouse Point is on Sanibel Island, a barrier island.

Why are the beaches and barrier islands so special?

If you've ever caught a wave in the water or found a shell in the sand, you already know why beaches are special. And barrier islands? Well, their name says it all.

Barrier islands protect the mainland coast by providing a block, or "barrier," against wind and ocean waves. This is particularly important in Florida where hurricanes are a common occurrence. The beaches and barrier islands also protect the habitats and nurseries along the coast. Why is this important? The nurseries are where countless young sea creatures are born or hatched every year!

What can I see at beaches and barrier islands?

Water, sand, and shells for sure! And of course, the birds. Brown pelicans dive into the water. Seagulls screech in the sky above. Stately herons and egrets stand tall in the island marshes.

If you're lucky, you might spot a manatee!

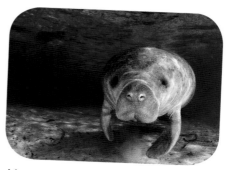

This huge marine mammal has a close relative that walks on land. Can you guess what it is? If you said the elephant, you're right! Manatees live in lots of watery habitats—from freshwater rivers and springs to saltwater bays and shallow coastal areas.

Manatees are protected in Florida.

Rivers and Lakes

The St. Johns River runs through the city of Jacksonville.

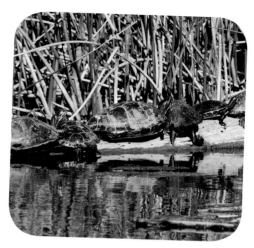

Suwannee River Cooter Turtles crowd onto a log.

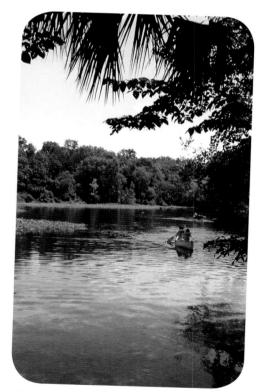

Floridians can enjoy a peaceful paddle around many lakes and rivers throughout the state.

The state of Florida has lots of large and little lakes and thousands of miles of rivers. The St. Johns River is Florida's longest. The Suwannee River was made famous in a tune Stephen Foster wrote—which became Florida's official state song in 1935.

Lake Okeechobee is the largest lake in the Southeast. Okeechobee means "big water" in the Seminole language. Okeechobee supplies southern Florida with most of its water.

Why are the rivers and lakes so special?

Lakes and rivers provide recreation, transportation, food, and habitats! Some of the water in lakes and rivers can be used to water crops. However, most importantly, water is needed for drinking. Residents depend on lakes, rivers, and aquifers to supply enough water to quench their statewide need.

Wait...what's an aquifer?

Underneath Florida's soil is a layer of limestone—a soft rock that dissolves to create cavities for underground water. This water can then bubble to the surface as freshwater springs. Florida has lots of these freshwater springs—two of the largest are Wakulla and Silver Springs.

Well, how about...
the history!

Tell Me a Story!

Native Americans have always made their homes throughout Florida. By the 16th century, such tribes as the Choctaw, Creek, Apalachee, Miccosukee, Timucua, and Calusa lived in Florida. By this time Spanish explorers also had come to the state.

In the early 1700s the Seminole tribe formed. They were Native Americans from Georgia and Florida who banded together for protection. Some African Americans who escaped from slavery came to Florida and joined the Seminoles, too.

You often hear people speak of these Native American tribes because many places throughout the state are named in their honor. Apalachee Bay, Tallahassee, Ocala—these names all honor the groups of people who first lived on Sunshine State land.

Seminole women still make dolls from palmetto fibers. One palmetto plant supplies enough fiber for four or five dolls.

...The Story Continues

During the 18th century, the Spanish, French, and British fought over Florida's land. However, in 1821 the United States bought Florida from Spain. Eventually, Florida became home to many other groups including European, American, Mexican, Cuban, and Caribbean settlers, and African Americans.

Floridians have always been educators, inventors, painters, writers, singers, and much more. Many footprints are stamped into the soul of Florida's history. You can see evidence of this all over the state!

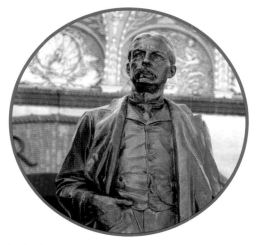

In the late 1800s, Henry M. Flagler developed hotels and railroads that helped encourage more people to visit Florida.

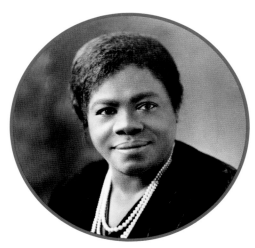

Mary McLeod Bethune was an educator and civil rights leader who lived in Daytona Beach.

Thomas A. Edison had a winter estate in Fort Meyers.

Monuments

Some of the walls that still stand at the Castillo de San Marcos National Monument site.

Monuments honor special people or events. Pedro Menéndez de Avilés founded St. Augustine in 1565. (It's the oldest city in the United States settled by Europeans!) In the 1600s, Castillo de San Marcos was built by the Spanish to protect their interests in this area. It's now a national monument in St. Augustine.

Why are Florida monuments so special?

That's an easy one! The hundreds of monuments and memorials throughout the state honor many special people who helped build the state of Florida. Some were famous explorers, soldiers, and politicians. Others were just ordinary people who did extraordinary things to shape the state—and the nation.

What kind of monuments can I see in Florida?

There are statues, plaques, landmarks, bridges, named streets—almost every town has found some way to honor a historic person or event.

Where are landmarks located?

Anywhere! The Flagler Memorial Island is an artificial island built to honor Henry Flagler, the "Father of Miami."

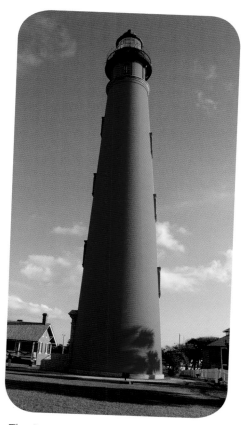

The Ybor City neighborhood in Tampa is a National Historic Landmark District. It was named after Vicente Martinez Ybor.

The Ponce de Leon lighthouse is a National Historic Landmark. It's named after the inlet where it is located—but its name also honors the famous Spanish explorer who named Florida!

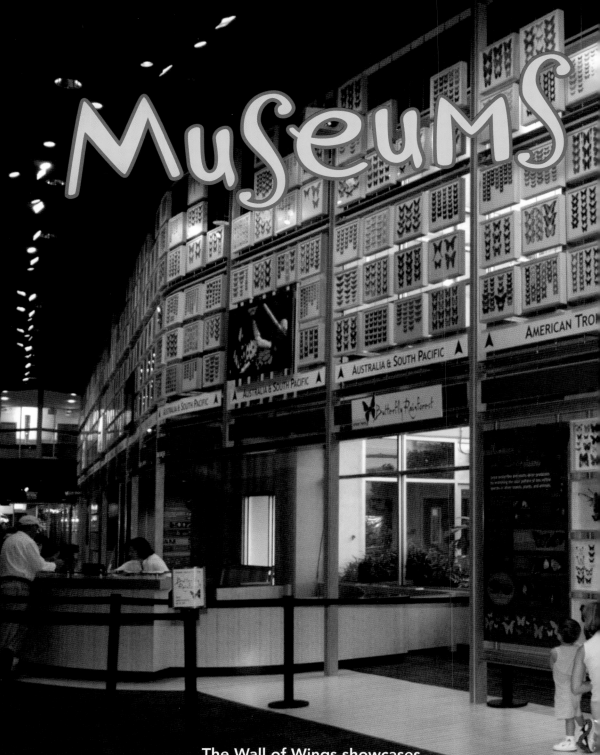

MuSeumS

The Wall of Wings showcases
thousands of butterflies and moths at the
Florida Museum of Natural History in Gainesville.

Museums don't just tell you about history—they show you things. How? With artifacts, of course! Museum artifacts are objects or models of objects. Either way, they make history come alive!

Why are Florida's museums so special?

Florida's museums contain amazing exhibits with artifacts that tell the story of the Sunshine State. At the Museum of Florida History in Tallahassee you can find out how tall a mastodon stood, examine gold coins from an 18th-century Spanish shipwreck, or learn how soldiers set up a Civil War campsite.

Some museums are even underwater!

Florida has underwater archaeological preserves. For example, the obsolete battleship USS *Massachusetts* was towed to Pensacola in 1921. It was used by the military for target practice—then it was sunk. Today the remains of the ship serve as a giant artificial reef for marine life in the Gulf of Mexico.

What can I see in a museum?

An easier question to answer might be, "What can't I see in a museum?" There are thousands of items in different museums across the state.

You can see a real Apollo 14 moon rock at the South Florida Science Museum in West Palm Beach. Do you want to know about swimming, diving, and water sports? The International Swimming Hall of Fame Museum in Fort Lauderdale is loaded with stories and memorabilia.

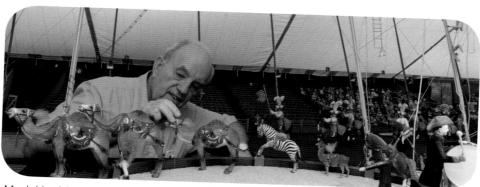

Model builder Howard C. Tibbals created a small model of the Ringling Bros. and Barnum & Bailey Circus. The model takes up more than 3,800 square feet in the Circus Museum's Tibbals Learning Center in Sarasota!

MiSSioNS

Church at the Mission San Luis de Talimali in Tallahassee

The first Spanish mission in North America—The Nombre de Dios Mission—was founded just north of St. Augustine way back in the 1500s.

Why were missions built? (....and what is a mission, anyway?)

Back in the 16th and 17th centuries, leaders in Spain wanted to grow their presence in Florida. A good way to do this was to establish religious missions. A mission had a church, village, workshops, and fields where Native Americans did most of the work. A presidio, or fort, where Spanish soldiers lived was usually built nearby.

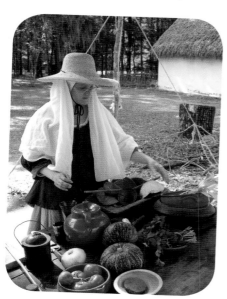

Food is prepared 17th-century style at Mission San Luis.

What can I see if I visit a mission today?

Florida once had over 100 missions, but the majority are now gone. However, the Mission San Luis de Talimali in Tallahassee is restored and open for public tours. If you visit, you'll journey back to the 17th century and discover what life was like for the Apalachee and Spanish residents. More than 950,000 artifacts have been found at the site.

Mission San Luis hosts many community events. In 2009 it even held its first Chihuahua Parade. (This breed of small dogs originated in Pre-Columbian Mexico—and they may have been the first breed of dog in the Americas.)

This little dog was a participant in the Mission San Luis Chihuahua Parade.

Well, how about...
the people!

Enjoying the Outdoors

More than 18 million people call Florida their home. Though they have different beliefs and traditions, Floridians also have plenty in common.

A mild climate throughout the Sunshine State allows people to enjoy the outdoors all year round. Most Floridians share a love of nature. Swimming, fishing, hiking, shell collecting—the list of things that Floridians enjoy goes on and on! Since the natural environment is so important to Floridians, most feel a shared responsibility to take care of it.

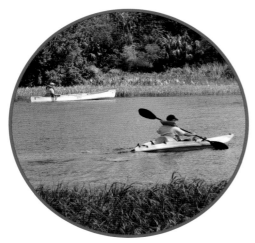

Kayaking is popular in the John D. MacArthur Beach State Park.

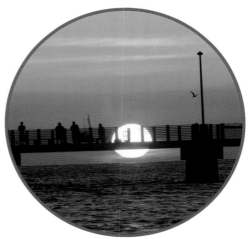

Sunset is a beautiful time of the day on this Fort De Soto Fishing Pier in St. Petersburg.

Sharing Traditions

In the towns and cities throughout the state, Floridians share the freedom to honor many different heritages. At the Silver Spurs Rodeo in Kissimmee, there's a lot of hoof-kicking excitement in honor of cattle ranchers and cowboys. The Miami/Bahamas Goombay Festival in Coconut Grove celebrates traditional Caribbean culture with traditional music, dance, and crafts.

Cooking is another way to pass on traditions. French, Spanish, African American—the recipes served on tables in Florida come from many different cultures! Traditional southern dishes with a Creole and Cajun flair are popular. So are Cuban and Caribbean specialties. Florida's fresh fish, fruits, and vegetables add flavor to any recipe!

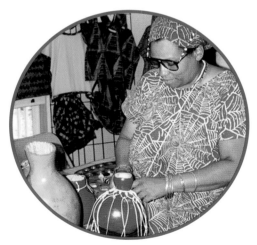

An artist demonstrates her craft with gourds at the Stephen Foster Folk Culture Center State Park.

Steak, white rice, black beans, and *maduros*—fried sweet plantains— make a tasty Cuban dinner.

Everglades National Park

Protecting

This Loggerhead Turtle is going back to the sea after being helped at the Loggerhead Marinelife Center in Juno Beach.

Protecting Florida's natural resources is a full-time job for many people!

Why is it important to protect Florida's natural resources?

The state of Florida has lots of different environments within its borders. This means many different kinds of plants and animals can live throughout the state. In technical terms, Florida has great biodiversity! This biodiversity helps maintain a healthy balance in ecosystems.

Where can I find places that protect plants and animals?

Well, pelicans enjoy their own private property at the Pelican Island National Wildlife Refuge east of Sebastian. Founded in 1903 by Theodore Roosevelt, this oldest national wildlife refuge in the United States provides a protected place for pelicans—and other animals such as manatees and sea turtles.

The John Pennekamp Coral Reef State Park in Key Largo even has an underwater refuge. Glass-bottom boats allow visitors to view the living coral reef!

Who protects these resources?

It takes a lot of groups to protect everything. The U.S. Fish and Wildlife Service is a national organization. The Florida Department of Parks and Recreation is a state group. Of course, many smaller groups also help.

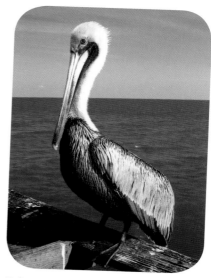

Pelicans and other birds can find safe nesting areas at Pelican Island.

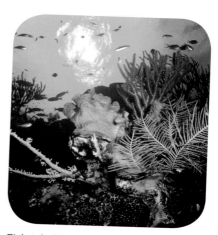

Fish inhabit the underwater coral reef at John Pennekamp State Park.

And don't forget...

You can make a difference, too. It's called "environmental stewardship," and it means that you are willing to take personal responsibility to help protect the Sunshine State's natural resources.

21

Creating Jobs

The space shuttle *Atlantis* launches into the sky.

The Kennedy Space Center employs lots of people (like scientists, engineers, technicians, and astronauts) to keep NASA's space programs going strong.

Plenty of chefs are needed to prepare food for all the tourists in Florida!

Florida produces more oranges and grapefruits than any other state

Military training is hard work!

What's the biggest industry in the state?

Warm weather, hundreds of miles of beaches, and spectacular amusement parks attract more than 70 million visitors to the Sunshine State each year. So it's no surprise that tourism is the number one business in Florida. Many jobs are needed to help people sightsee, dine, and relax!

Any other jobs?

Absolutely! Cattle farming and agriculture have always been important to the state. Florida leads the nation in growing oranges and grapefruits.

Florida is also one of the fastest-growing states in the life science industry. Many people in this industry focus on research and treatments of diseases.

Don't forget the military!

The Air Force, Army, Navy, Marine Corps, and Coast Guard all have a presence in the state. Whether training or working, the brave men and women who serve our country are held in great respect throughout Florida.

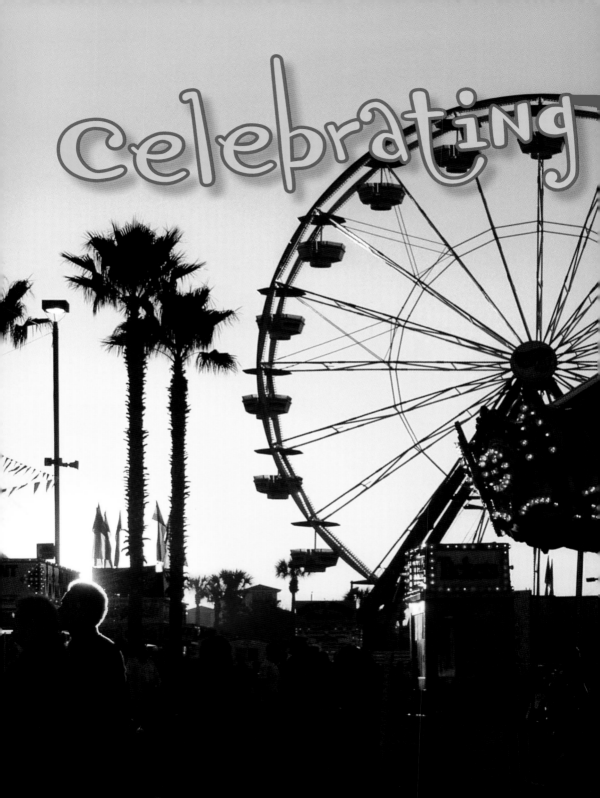

Celebrating

The Florida State Fair is held in Tampa.

The people of Florida work hard, but they also know how to have fun! The State Fair draws tens of thousands of people to Tampa each year.

Why are Florida festivals and celebrations special?

Celebrations and festivals bring people together. Some celebrate music and cooking. Others celebrate arts and crafts. All celebrate the people of Florida and their talents.

What kind of festivals are held in Florida?

Too many to count! But one thing is for sure; you can find a celebration or festival for just about anything you want to do. Want to hear great Latin music? Then the Calle Ocho festival in Miami is for you. In 1988 a world record was set at this festival when more than 119,000 people formed the world's longest conga line!

Would you like to watch the best stock car racers in the world compete? Then start your engines and head for the International Speedway in Daytona Beach.

The Florida Strawberry Festival in Plant City is a tasty celebration.

Don't forget the underwater pumpkin-carving contest!

Each October the fish move over in Key Largo! That's when SCUBA divers take the plunge with their pumpkins to try to carve the perfect jack-o'-lantern on the ocean floor!

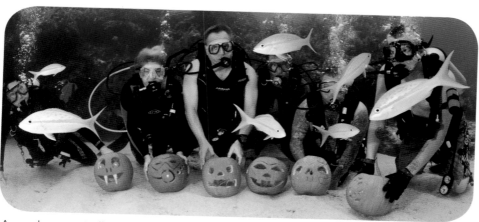

An underwater Halloween scene in Key Largo!

Birds and Words

What do all the people of Florida have in common? These symbols represent the state's shared history and natural resources.

State Bird
Mockingbird

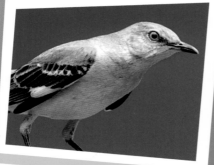

State Tree
The Sabal Palm

State Flower
Orange Blossom

State Butterfly
Zebra Longwing

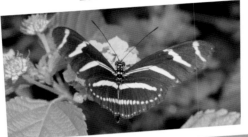

State Flag
Adopted 1900

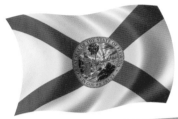

State Reptile
American Alligator

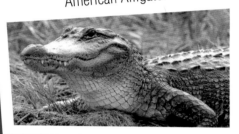

State Animal
Florida Panther

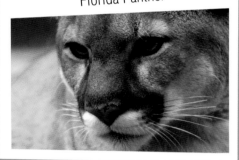

State Saltwater Mammal
Dolphin

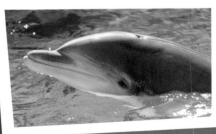

State Fruit
Orange

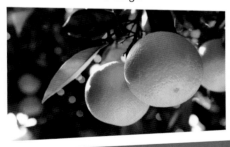

Want More?

Statehood—March 3,1845
State Capital—Tallahassee
State Nickname—Sunshine State
State Song—"The Swanee River (Old Folks at Home)"

State Wildflower—Coreopsis
State Horse—Cracker horse
State Marine Mammal—Manatee
State Shell—Horse Conch
State Gem—Moonstone
State Beverage—Orange juice
State Pie—Key Lime pie

More Fun Facts

More

Here's some more interesting stuff about Florida!

Dog-Sized Deer

The Florida Keys are home to the key deer—which only grow to be about two feet tall.

Low High Point

Florida's highest elevation (Britton Hill in the Florida Uplands) is only about 345 feet above sea level.

Live Mermaids

Underwater performers dressed like mermaids delight audiences at the **Weeki Wachee** Springs State Park.

720,000 Safe Acres

The Big Cypress National Preserve was one of the first national preserves to be established by Congress.

Downside to a Great Location

Florida has more than 1,300 miles of coastline with 800 miles of beaches. Unfortunately, it is also the most hurricane prone state in the United States.

Florida Fun

With attractions like SeaWorld, Walt Disney World Resort, and Universal Studios, **Orlando** welcomes around 70 million tourists each year. This includes millions of visitors from international locations, too!

Famous First

The first American astronaut to orbit the Earth, John Glenn, launched from Cape Canaveral on February 20, 1962.

Dominoes, anyone?

The Cuban neighborhood in **Miami**—Little Havana—is named after Cuba's capital city.

Alligator Alley

That's the nickname of the Everglades Parkway—a road that crosses east to west through the wetlands.

Cracker Cows

The Spanish introduced cattle to Florida in the 16th century. The descendents of the old Spanish stock—called Cracker Cows—are highly resistant to disease and tolerate the warm Florida weather very well.

Farther South

Although it is the southernmost state in the *continental* United States, Florida is not the southernmost state in the *entire* United States. Hawaii is farther south!

Gator Aid

Gatorade was developed to help the University of Florida football team—the Gators—stay hydrated.

A Flowery Name

Ponce de Leon—the Spanish explorer who first landed in Florida in 1513—named the area "la Florida" in honor of Spain's Easter-time feast of the flowers celebration.

Tree Soup

Gumbo limbo is one kind of tree that grows in the hammocks—or tree islands—that stand throughout the Everglades.

Watch Your Step!

Devils Millhopper State Park in **Gainesville** is home to a 120 foot deep sinkhole. Sinkholes form when limestone is gradually worn away.

Comfy Sand

The sand on the beaches in such places as **Destin** and **Pensacola** is sugary white and soft. Why? It's mainly made of quartz washed down from the Appalachian Mountains.

Find Out More

There are many great websites that can give you and your parents more information about all the great things that are going on in the state of Florida!

State Websites

The Official Website of the State of Florida
www.myflorida.org

Florida State Parks
www.floridastateparks.org

Museums/Clewiston

Seminole Tribe of Florida Ah-Tah-Thi-Ki Museum
www.ahtahthiki.com

Deland

African American Museum of the Arts
www.africanmuseumdeland.org

Fort Lauderdale

Fort Lauderdale Museum of Discovery and Science
www.mods.org

Jacksonville

The Museum of Science and History
www.themosh.org

Miami

Miami Children's Museum
www.miamichildrensmuseum.org

Miami Science Museum
www.miasci.org

Orlando

Orlando Science Center
www.osc.org

Orange County Regional History Center
www.thehistorycenter.org

St. Petersburg

St. Petersburg Museum of History
www.spmoh.org

The Florida Holocaust Museum
www.flholocaustmuseum.org

Tallahassee

Tallahassee Museum
www.tallahasseemuseum.org

Tampa

Tampa Museum of Art
www.tampamuseum.org

Museum of Science and Industry
www.mosi.org

Aquarium and Zoos

The Florida Aquarium
www.flaquarium.org

Lowry Park Zoo
www.lowryparkzoo.com

Jacksonville Zoo and Gardens
www.jacksonvillezoo.org

Florida: At A Glance

State Capital: Tallahassee

Florida Borders: Georgia, Alabama, Gulf of Mexico, Straits of Florida, and the Atlantic Ocean

Population: Over 18 million

Highest Point: Britton Hill is 345 feet (105 meters) above sea level

Lowest Point: Sea level on the coasts

Some Major Cities: Miami, Orlando, Jacksonville, Tallahassee, Tampa

Some Famous Floridians

Zora Neale Hurston (1891–1960); lived in Eatonville; was a writer who was known for portraying African-American rural life.

Andrew Jackson (1767–1845); was the governor of the Florida Territory and the seventh president of the United States.

Sidney Poitier (born 1927); from Miami; is an Academy Award-winning actor, artist, writer, and director.

Marjorie Kinnan Rawlings (1896–1953); was a Cross Creek area Pulitzer Prize-winning author of books about rural life.

Julia D. Tuttle (1848–1898); was considered the "Mother of Miami" for her influence in opening the city to tourists.

Marjory Stoneman Douglas (1890–1998); was an environmentalist and writer dedicated to preserving the Everglades.

Gloria Estefan (born 1957); is a Miami-based Grammy Award-winning Cuban-American singer and songwriter.

Henry Flagler (1830–1913); was a businessman who built railroads and hotels that helped transform Florida.

John Gorrie (1803–1855); was a physician and scientist who is considered the father of air conditioning and refrigeration.

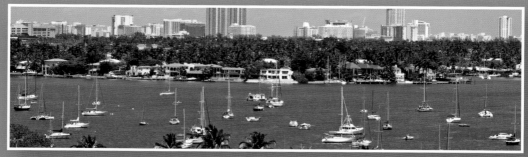

Boats are plentiful in Biscayne Bay.

CREDITS

Series Concept and Development
Kate Boehm Jerome

Design
Steve Curtis Design, Inc. (www.SCDchicago.com), Roger Radtke, Todd Nossek

Reviewers and Contributors
Stacey L. Klaman, writer and editor; Mary L. Heaton, copy editor; Eric Nyquist, researcher;
Neville Bhada, Southeast Tourism Society

Photography
Back Cover(a), 6-7 © S. Borisov/Shutterstock; Back Cover(b) © Katherine Welles/Shutterstock; Back Cover(c), 18-19 © Angelo Garibaldi/Shutterstock; Back Cover(d) © Samot/Shutterstock; Back Cover(e), 27f © April D/Shutterstock; Cover(a), 2a, 7b © A Cotton Photo/Shutterstock; Cover(b), 26c © Beata Becla/Shutterstock; Cover(c) © Nickolay Khoroshkov/Shutterstock; Cover(d), 2-3 © ciapix/Shutterstock; Cover(e) © gary718/Shutterstock; Cover(f), 9a © Denis Blofield/Shutterstock; 2b © Lorna Boyajian/Shutterstock; 3a © Aaron Whitney/Shutterstock; 3b © Deror avi/Wikimedia; 4-5 © FloridaStock/Shutterstock; 5a © Martha Marks/Shutterstock; 5b © worldswildlifewonders/Shutterstock; 5c © Jonathan G/Shutterstock; 7a © Daniel Korzeniewski/Shutterstock; 8-9 © 4531632660/Shutterstock; 9b © Ishbukar Yaliilfatar/Shutterstock; 10-11 © Jim Steinhart of TravelPhotoBase.com; 10a © CLM/Shutterstock; 11a Theskeptic/Wikimedia; 11b Scurlock, Archives Center, National Museum of American History, Smithsonian Institution; 12-13 © Natalia Bratslavsky/Shutterstock; 13a © Krystal Rizzo; 13b © gracious_tiger/Shutterstock; 14-15 by Jeff Gage/Florida Museum; 15 © The John and Mable Ringling Museum of Art; 16-17, 17a © Courtesy Mission San Luis, Florida Division of Historical Resources; 17b Al Hall/Courtesy Mission San Luis, Florida Division of Historical Resources; 18a, 19a, 21b Courtesy Florida Department of Environmental Protection; 18b © Jeff Kinsey/Shutterstock; 19b © Chris Bence/Shutterstock; 20-21 © Courtesy Deb Mauser, Loggerhead Marinelife Center, Juno Beach, FL; 21a © aceshot1/Shutterstock; 22-23 Courtesy NASA; 23a © erwinova/Shutterstock; 23b, 27a © Lori Skelton/Shutterstock; 23c © John Wollwerth/Shutterstock; 24-25 Courtesy Tampa Bay & Company; 25a © Martin Kubát/Shutterstock; 25b © Bob Care/Florida Keys News Bureau; 26a, © Steve Byland/Shutterstock; 26b William Bumgarner (en.wp:Zsinj)/Wikimedia; 27b © Pakmor/Shutterstock; 27c © Todd S. Holder/Shutterstock; 27d © mlorenz/Shutterstock; 27e © Bobby Deal/RealDealPhoto/Shutterstock; 28 © Tom Hirtreiter/Shutterstock; 29a © Joseph/Shutterstock; 29b © Joao Virissimo/Shutterstock; 31 © R. Gino Santa Maria/Shutterstock; 32 © Paul Picone/Shutterstock

Illustration
Back Cover, 1, 4 © Jennifer Thermes/Photodisc/Getty Images

ISBN 978-1-58973-013-7

Library of Congress Catalog Card Number: 2009943363

1 2 3 4 5 6 WPC 15 14 13 12 11 10

Published by Arcadia Publishing
Charleston SC, Chicago IL, Portsmouth NH, San Francisco CA

For all general information contact Arcadia Publishing at:
Telephone 843-853-2070
Fax 843-853-0044
Email sales@arcadiapublishing.com
For Customer Service and Orders:
Toll Free 1-888-313-2665

Visit us on the Internet at www.arcadiapublishing.com